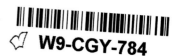

DOVER MASTERWORKS

Color Your Own

MODERN ART

Paintings

Rendered by
Muncie Hendler

Dover Publications, Inc.
Mineola, New York

Note

Is it possible to create your own Picasso? Or an original Matisse? It is, with this collection of 30 black-and-white line renderings of masterworks of modern art, which will allow art lovers and aspiring artists to experiment by altering the colors and hues of the original paintings. How important are colors and tonal relationships to the meaning of the modern painting? Change them, and discover the answer for yourself. Included here are paintings by such modern art masters as Salvador Dali, Max Ernst, Gustav Klimt, Edvard Munch, Henri Rousseau, and more.

The thirty paintings are arranged alphabetically by the artist's last name, and are shown in full color on the inside covers for easy reference. Choose your media, and then follow the artist's color scheme if you prefer an accurate representation of the original work, or pick your own colors for a more personal touch. When you're finished coloring, the perforated pages make it easy to display your finished work. Captions on the reverse side of each plate identify the artist and title of the work, date of composition, and include interesting biographical facts about the artist.

Bibliographical Note

Dover Masterworks: Color Your Own Modern Art Paintings is a new work, first published by Dover Publications, Inc., in 2013. Plates 1, 5, 11, 13, 14, 16, 17, 19, 20–22, 25, 26, and 29 were reprinted from *Color Your Own Modern Art Masterpieces,* originally published by Dover in 1996.

International Standard Book Number

ISBN-13: 978-0-486-78024-5
ISBN-10: 0-486-78024-4

Manufactured in the United States by LSC Communications
78024407 2018
www.doverpublications.com

Guide to the Modern Art Paintings

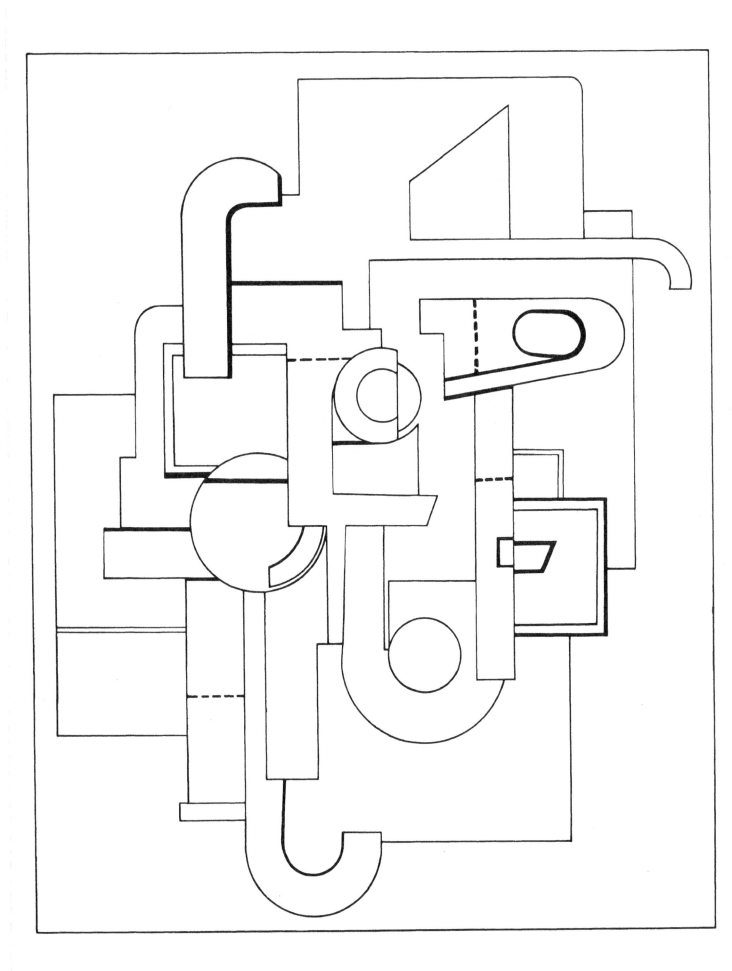

Plate 1
WILLI BAUMEISTER
Gouachemalning, 1923

One of the most important German painters of the modern era, Willi Baumeister apprenticed as a decorative painter before beginning his artistic studies at the Royal Academy of Stuttgart in 1907. His work first began to attract attention during World War I, though he did not gain an international reputation until Fernand Léger and Le Corbusier helped spread his work throughout Europe in 1922. Baumeister was prohibited by the Nazis from showing his work in Germany, though he was widely exhibited in London and Paris from 1933 until the end of World War II. This piece is typical of Baumeister's work during the early and mid-1920s, in its abstract representation of man and machines, in which the actual subject is almost completely unrecognizable beyond the painting's geometric shapes.

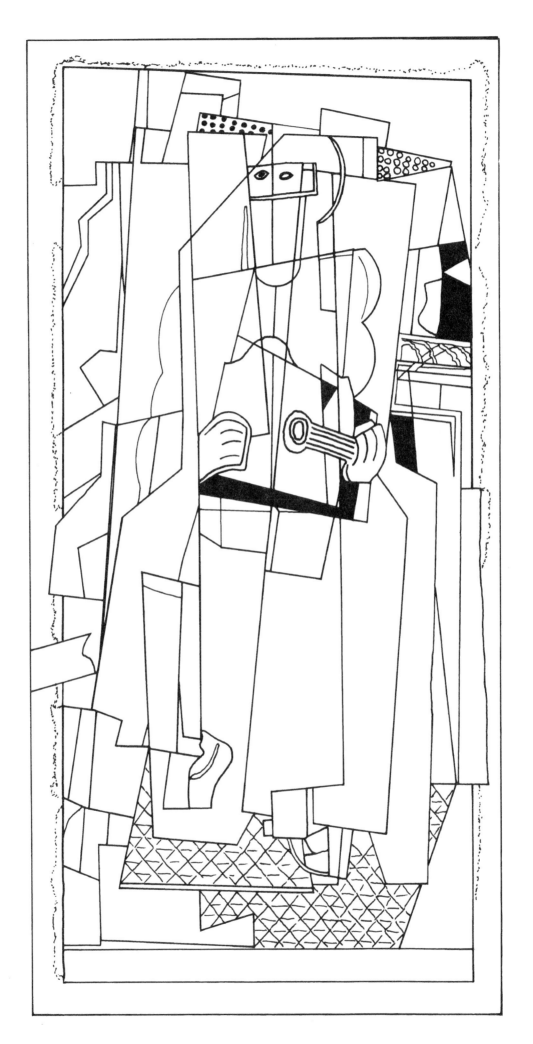

Plate 2
GEORGES BRAQUE
La Guitariste, 1917

Georges Braque was a French painter and sculptor, and one of the first artists (along with Pablo Picasso) to paint in the Cubist style. Born in Argenteuil, France, Braque was raised in Le Havre, where he studied painting at the École des Beaux-Arts. Before his work in the development of Cubism, Braque painted in both the Impressionist and Fauvist styles, exhibiting his work alongside such artists as Henri Matisse, André Derain, and Paul Cézanne. This painting features a musician with a guitar, reduced to simplified geometric form; it is a typical example of Braque's work from this period.

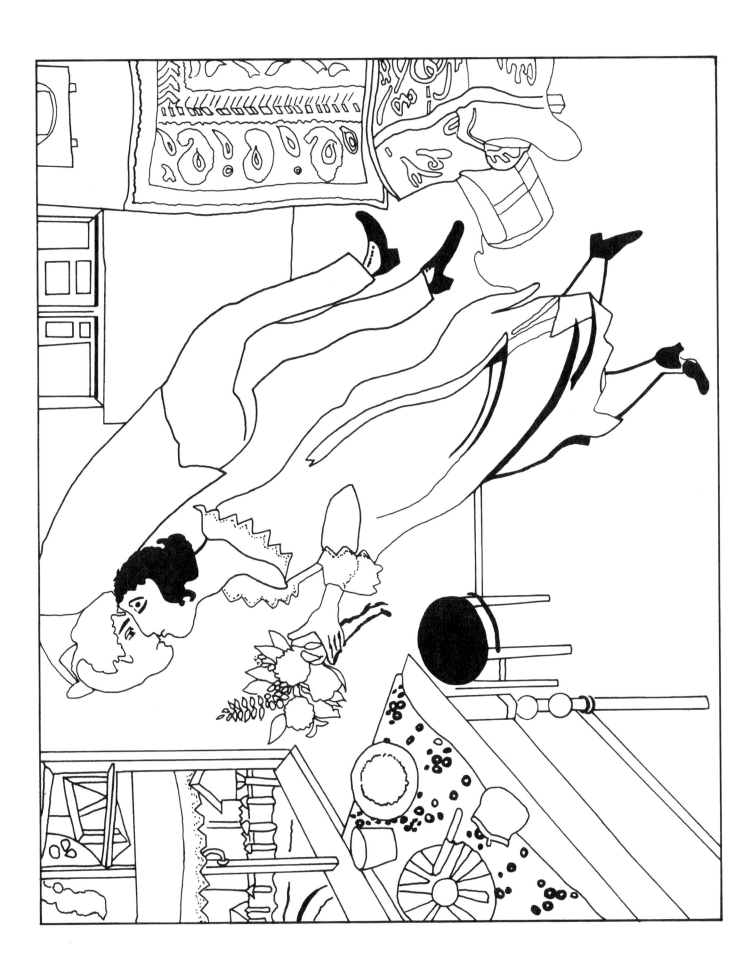

Plate 3
MARC CHAGALL
The Birthday, 1915

Russian-born painter and designer Marc Chagall developed a highly individual and personalized style, incorporating elements of Russian Expressionism, Surrealism, and Cubism. A unique blend of reality and dreams, his art is suffused with poetic imagery and striking visual metaphors. Most of his subject matter is rooted in the Russian-Jewish folklore of his childhood. His recurring motifs, such as rooftop fiddlers and floating brides, possess a surrealistic quality and frequently appear in a dreamlike setting. In his work, richly colored figures predominate within a loosely related series of images, providing a visual montage of Chagall's own life experiences. The subject of this painting is the artist and his bride-to-be, Bella. Painted just a few weeks before their wedding, this work is now in the collection of the Museum of Modern Art in New York.

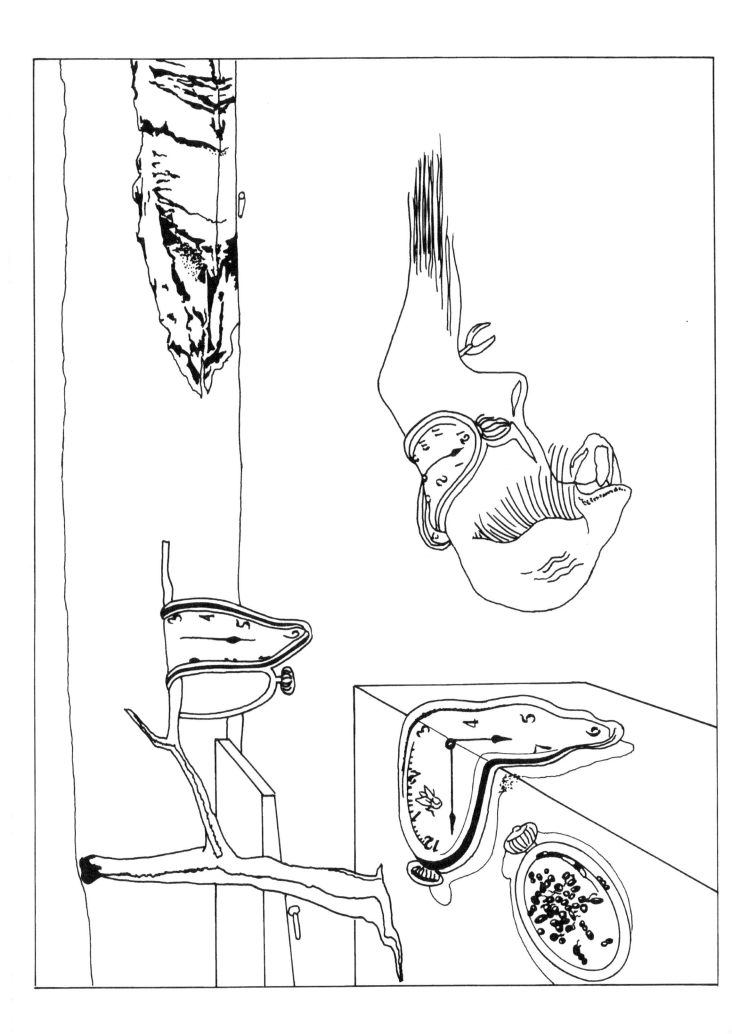

Plate 4
SALVADOR DALÍ
The Persistence of Memory, **1935**

Spanish painter Salvador Dalí studied at the Academy of Fine Arts in Madrid before moving to Paris. As a member of the Surrealist movement, Dalí promoted the idea of absurdity and the role of the unconscious in his art. Influenced by the psychoanalytic theories of Freud and abnormal psychology in general, he developed a range of unforgettable imagery, including distortions of the human form and limp watches, as seen in *The Persistence of Memory,* Dalí's most well-known painting. He also painted religious themes as well as numerous portraits of his wife. This painting resides in the collection of the Museum of Modern Art in New York.

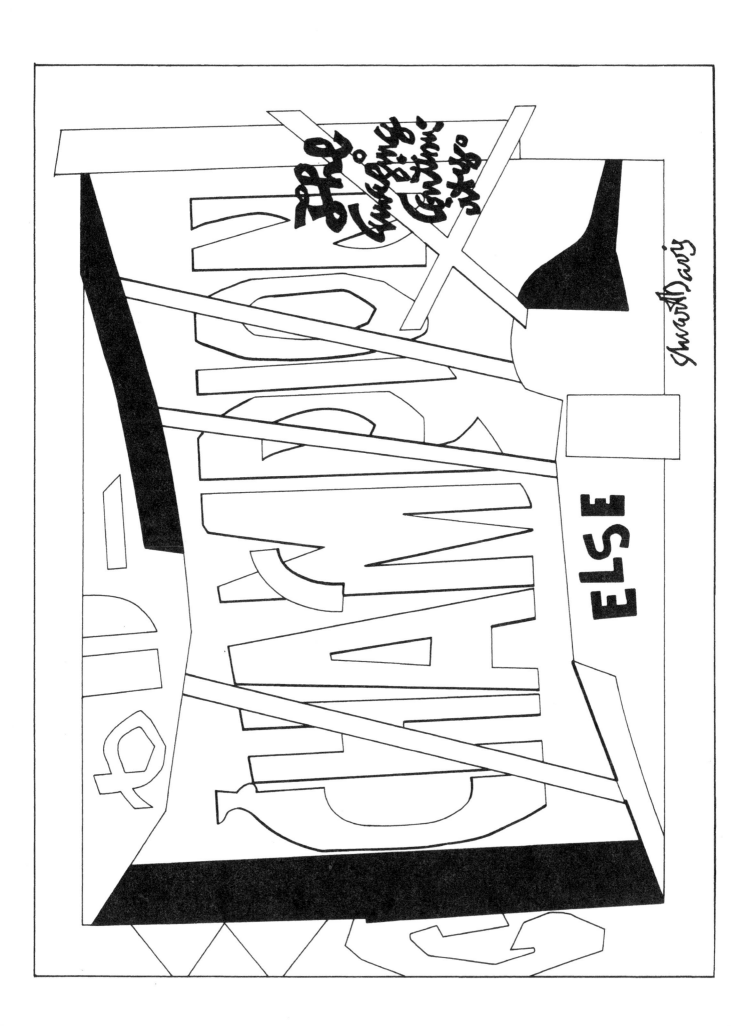

Plate 5
STUART DAVIS
Visa, 1951

Stuart Davis was born in 1892 into an artistic family, with his father serving as the art editor for the Philadelphia Press, and his mother working as a prominent sculptor. Davis worked in many different styles and genres, though he is most remembered as one of the earliest American modernist painters to experiment with pop art. In *Visa*, Davis composes the painting around a number of seemingly unrelated words, which he chose based as much on their aesthetic appeal as their meaning. While the central word—"Champion"—came from a matchbook-cover advertisement for spark plugs, the rest of the word choices are much more enigmatic. Additionally, he refused on several occasions to explain the title of the piece, saying only that it was "a secret because I believe in magic."

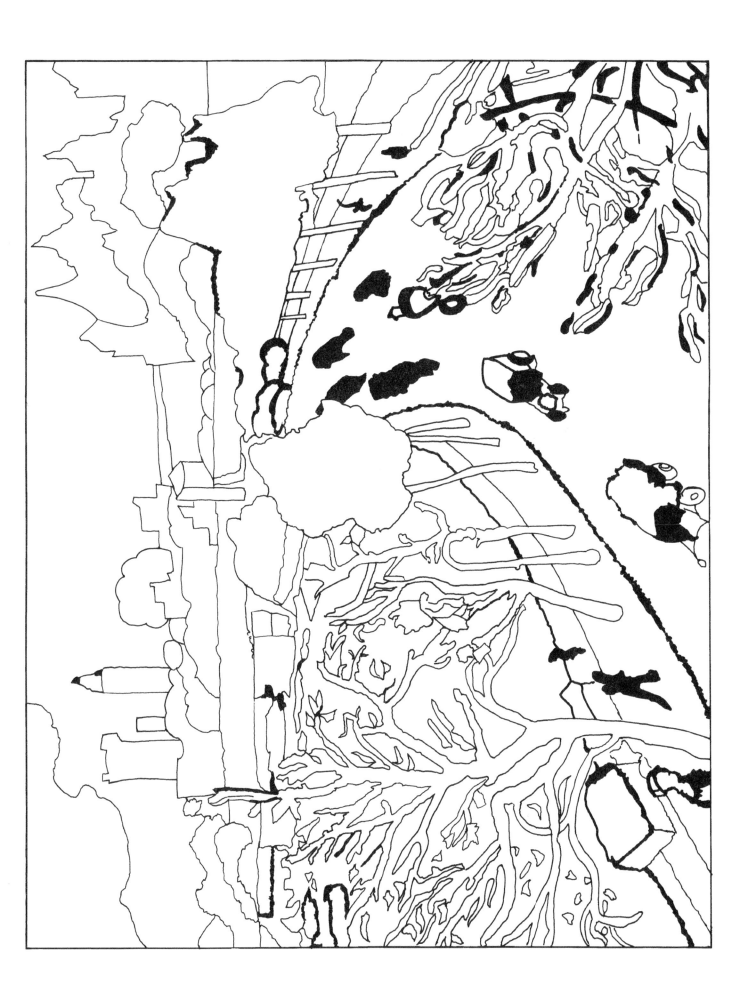

Plate 6
ANDRÉ DERAIN
Westminster Bridge, 1906

A major exponent of the Fauvist movement, Derain was born in Chatou, France. His style closely resembles Matisse and Vlaminck, with whom he shared a studio. Derain was one of the first artists to collect African art, which became a key source of inspiration for many early-twentieth-century artists. Influenced by the work of Cézanne as well as the early Cubist paintings of Picasso and Braque, Derain continued to experiment with different compositional techniques. Westminster Bridge, considered one of the finest examples of Fauvist painting, was one of 30 works that Derain painted during his two trips to London in 1906. It currently resides in the collection of the Musée d'Orsay in Paris.

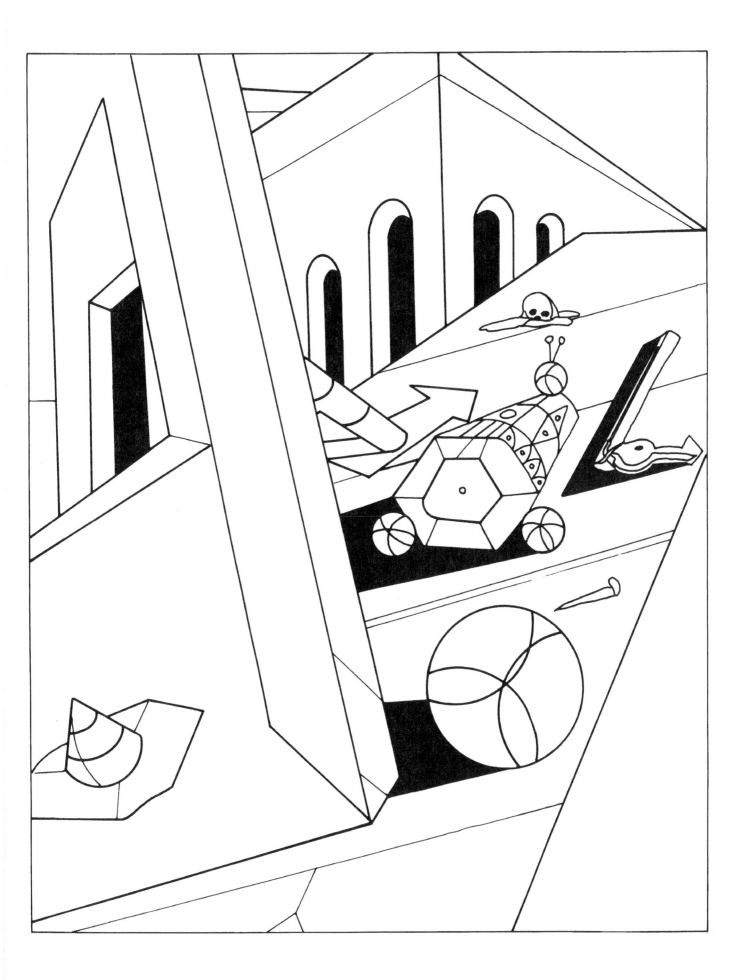

Plate 7
GIORGIO DE CHIRICO
The Evil Genius of a King, 1914–1915

Born to Italian parents in Volos, Greece, Giorgio de Chirico is best remembered as the founder of the *scuola metafisica* movement, which was extremely influential for Salvador Dalí and other surrealists. Giorgio de Chirico studied under Georgios Rios in Athens and at the Academy of Fine Arts in Munich before returning to his ancestral home in Italy in 1909. It was there that de Chirico produced the bulk of his most famous paintings, during what is known as his metaphysical period, lasting from 1909 to 1919. At the height of this period, de Chirico painted *The Evil Genius of a King*, which appears to be a group of children's toys which defy gravity as they sit suspended on a tilted plane.

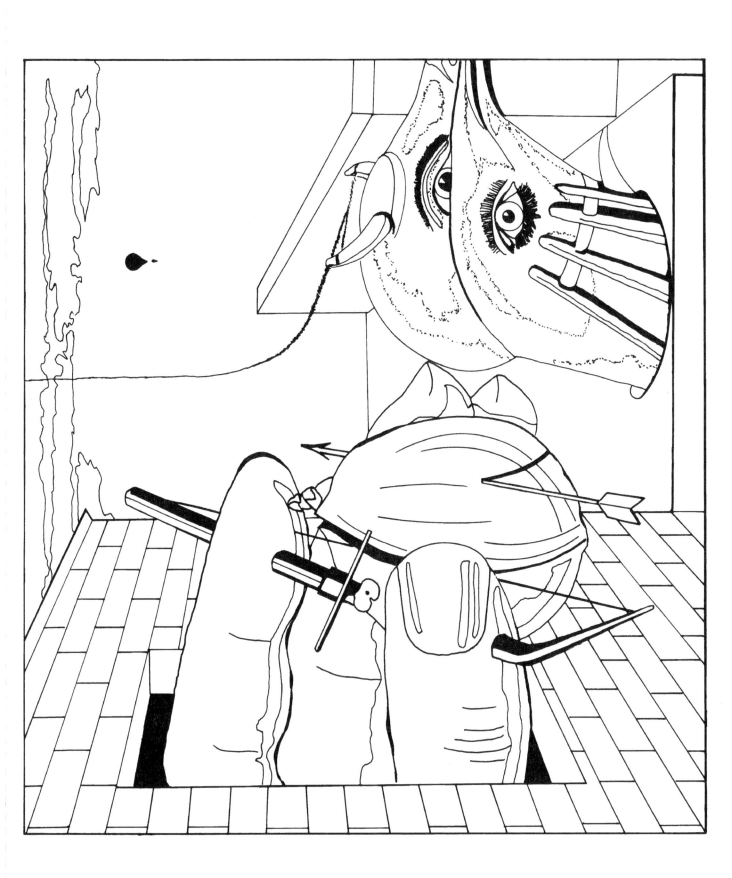

Born in Brühl, Germany, in 1891, Max Ernst was a prolific painter, sculptor, and poet, best remembered as a leading figure in both the Dada and Surrealist movements. Although he began producing art in 1909 while studying at the University of Bonn, Ernst's career as an artist truly began after returning to Cologne following four years in the military during World War I. Ernst was greatly influenced by the work of Giorgio de Chirico, Pablo Picasso, and Paul Gauguin, as well as contemporaries like Paul Klee. Ernst produced *Oedius Rex* while living in Cologne, shortly after forming the German Dada group with Jean Arp and Alfred Grunwald. The grotesque imagery and surreal composition are typical of Ernst's work from that period, and helped to make this painting one of the foundational works of the Dada movement.

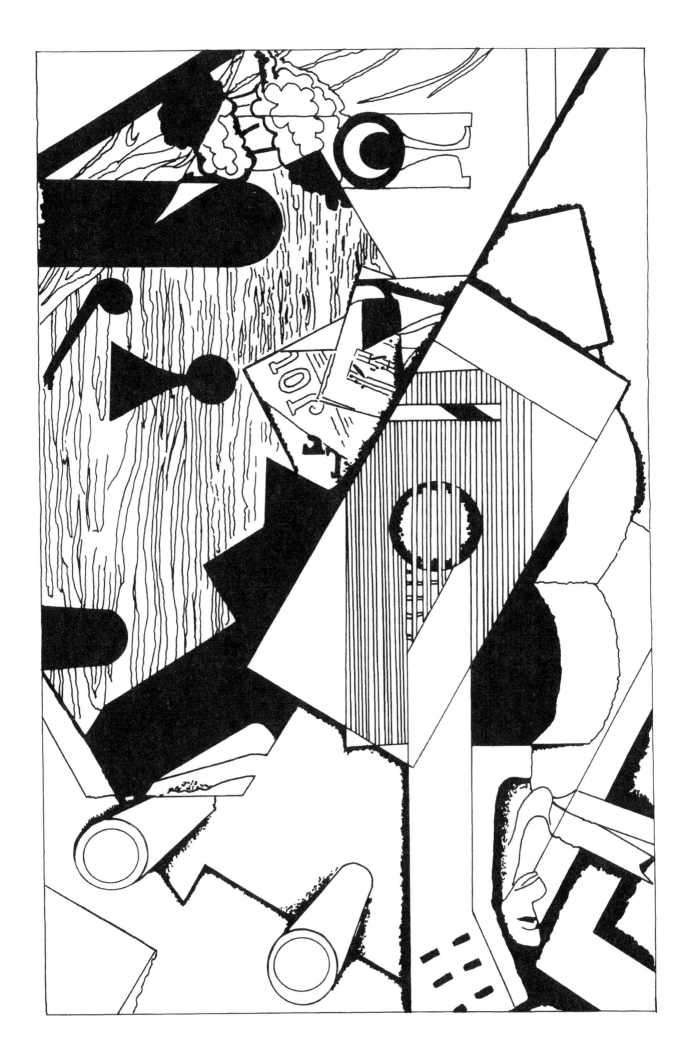

Plate 9
JUAN GRIS
Still Life with a Guitar, 1914

Born in Madrid, Spain, in 1887, Juan Gris spent the majority of his life and career in France, achieving great success as both a painter and sculptor. Although he began his career as a satirical cartoonist, he is best remembered for his work in the Cubist genre. After moving to Paris in 1906, Gris befriended Henri Matisse, Georges Braque, and Fernand Léger, each of whom had a great influence on his work. Gris greatly admired Pablo Picasso, and although the two are often associated together, it is believed that Picasso did not think much of Gris or his work. In this painting, common objects like a guitar, wine glass, and newspaper, are depicted in Gris's typical Cubist style. *Still Life with a Guitar* resides in the collection of the Metropolitan Museum of Art in New York.

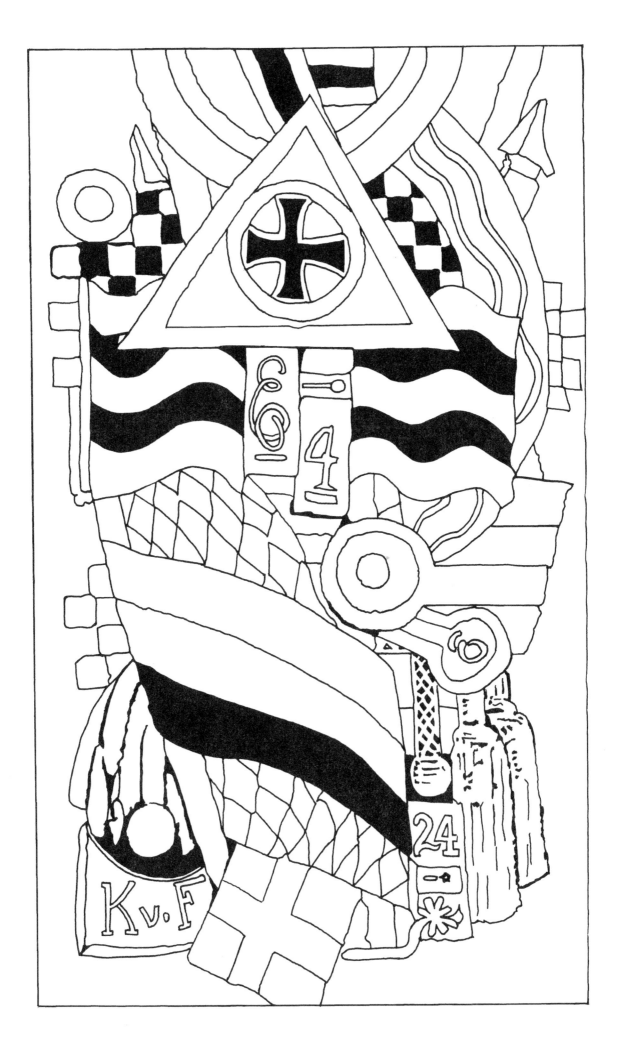

The youngest of nine children, Marsden Hartley was born and raised in Lewiston, Maine, and trained as an artist at the Cleveland Institute of Art, the New York School of Art, and the National Academy of Design. Inspired by the paintings of Albert Pinkham Ryder and the writings of Walt Whitman, Henry David Thoreau, and Ralph Waldo Emerson, Hartley viewed his art as a spiritual journey, through which he endeavored to express the essence of nature. His work had a profound influence on American Modernism, though he was also an important figure in the Regionalism movement as well. Hartley painted *Portrait of a German,* one of his most vivid abstractions, while living in Berlin during the early years of the First World War. It is currently in the collection of the Metropolitan Museum of Art in New York.

Plate 11
AUGUSTE HERBIN
Vein, 1953

Born and raised in Quiévy, France, Auguste Herbin studied at the École des Beaux-Arts de Lille before moving to Paris in 1901. Although his early works display a great deal of influence by the Impressionists and Post-Impressionists, Herbin is best remembered for his later work, which show a transition from Cubism to a more abstract, geometrical style. Like many of his later paintings, the composition of *Vein* is based on a complex system, set forth in his 1949 book *L'Art Non-Figuratif Non-Objectif*, which forms correspondences between specific colors, forms, letters, and musical notes.

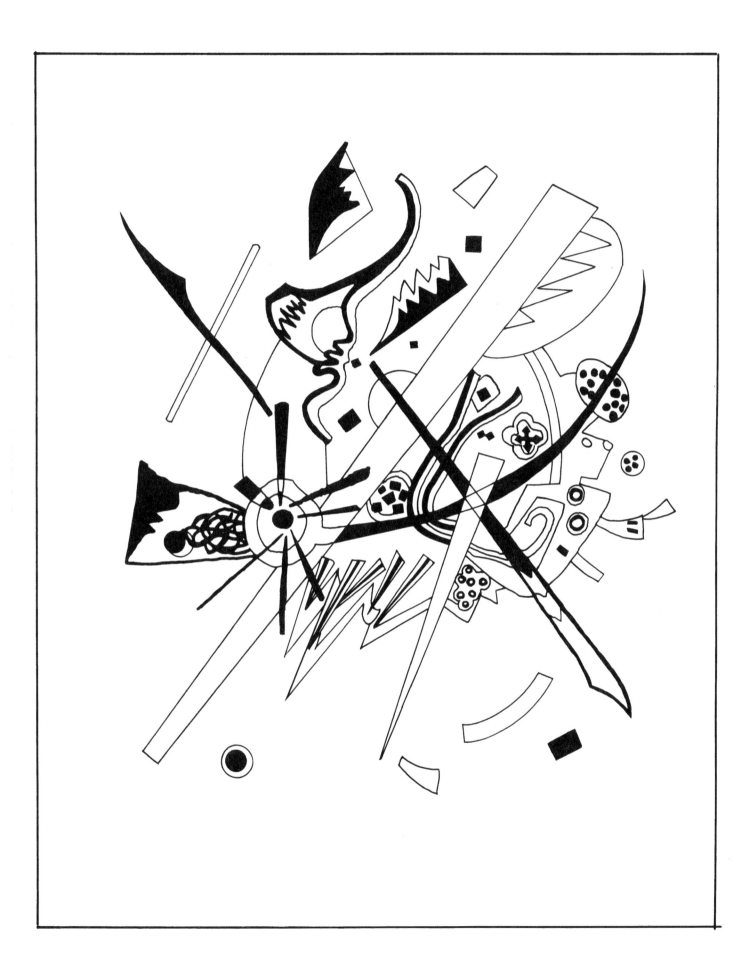

Plate 12
WASSILY KANDINSKY
Kleine Welten I, 1922

Although he is best remembered as the first painter of purely abstract works, Russian artist Wassily Kandinsky originally made a name for himself as an Impressionist painter, greatly influenced by the work of Claude Monet. His transition into abstraction began while studying at the Academy of Fine Arts in Munich, though he would not begin the starkly geometric abstract paintings for which he is best known until almost ten years later. *Kleine Welten I* is the first in a series of twelve prints, six lithographs, four drypoints, and two woodcuts. "Kleine Welten" literally translates as "Small Worlds."

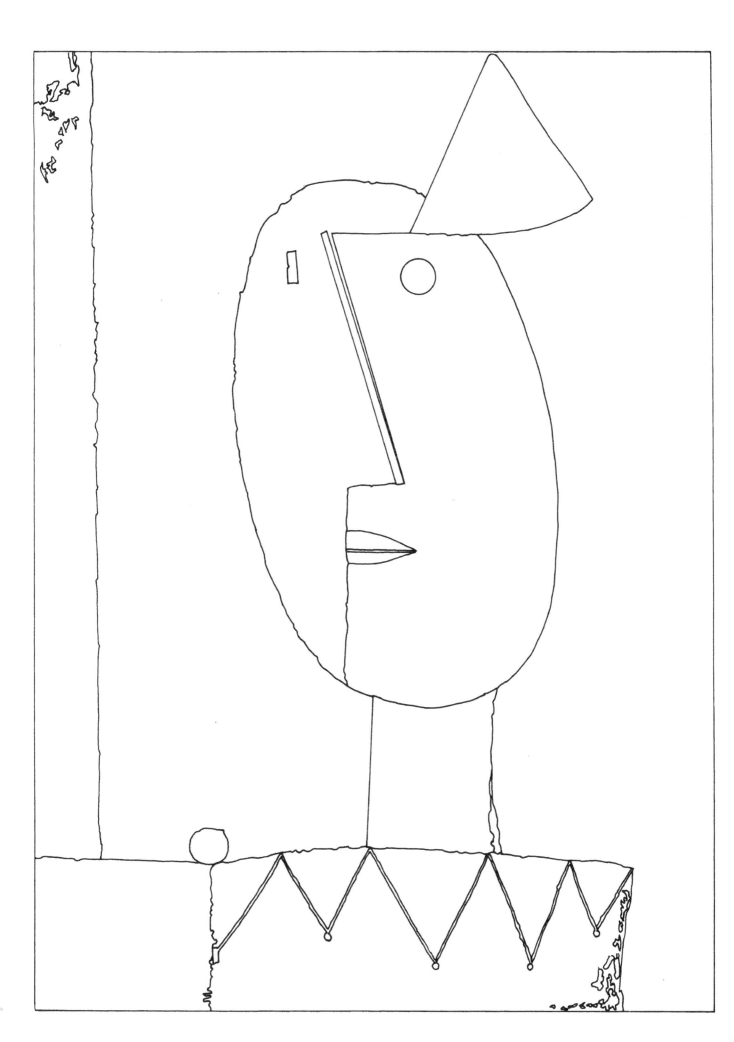

Born in Münchenbuchsee, Switzerland, in 1879, Paul Klee is considered one of the greatest Swiss painters of the modern era. Klee was greatly influenced by Expressionism, Cubism, and Surrealism, as well as by the Bauhaus school, where he worked alongside Wassily Kandinsky. Klee gained international success as an artist after his experiments with pure abstraction became popular throughout Europe during World War I. This painting, which depicts a Cubist representation of a clown, was typical of Klee's Bauhaus period in its use of rich, dark colors and inclusion of abstract graphical elements.

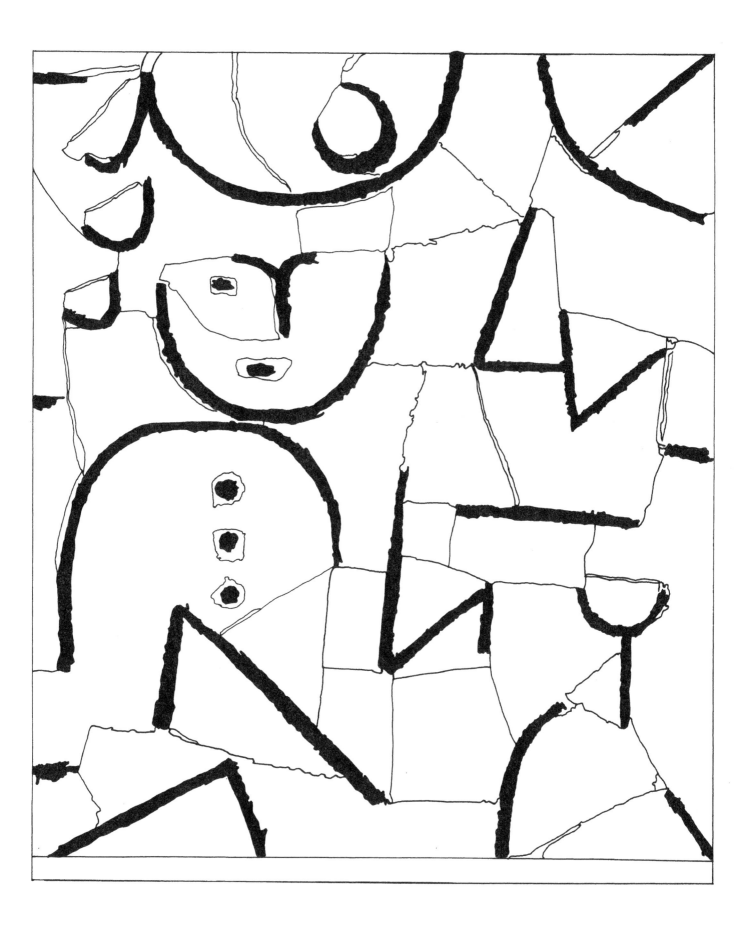

Plate 14
PAUL KLEE
Figure in a Garden, 1937

Born in Münchenbuchsee, Switzerland, in 1879, Paul Klee is considered one of the greatest Swiss painters of the modern era. Klee was greatly influenced by Expressionism, Cubism, and Surrealism, as well as by the Bauhaus school, where he worked alongside Wassily Kandinsky. Klee gained international success as an artist after his experiments with pure abstraction became popular throughout Europe during World War I. Like many of Klee's paintings from the later years of his life, *Figure in a Garden* uses fragmented figures with little detail to express a whimsy that is quite different from the melancholy which was typical of his earlier works.

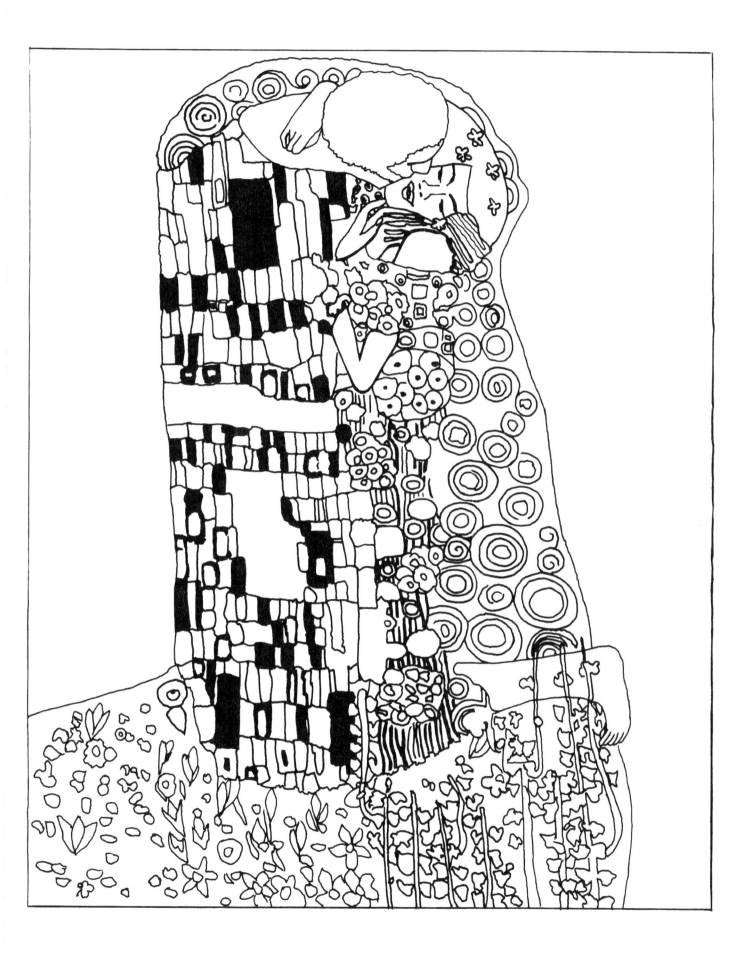

Plate 15
GUSTAV KLIMT
The Kiss, 1908

Born in Baumgarten, Austria, painter Gustav Klimt was one of the most well-known members of the Vienna Secession movement, which encouraged artists to revolt against academic art in favor of more decorative styles, such as Art Nouveau. Klimt was primarily a decorator, but he also produced murals and a number of portraits, as well as allegorical and mythical paintings. His work had a profound impact on Oskar Kokoschka and Egon Schiele. *The Kiss* is one of Klimt's most famous works. In it, a mass of patterns and shapes dominate his representation of a kissing couple.

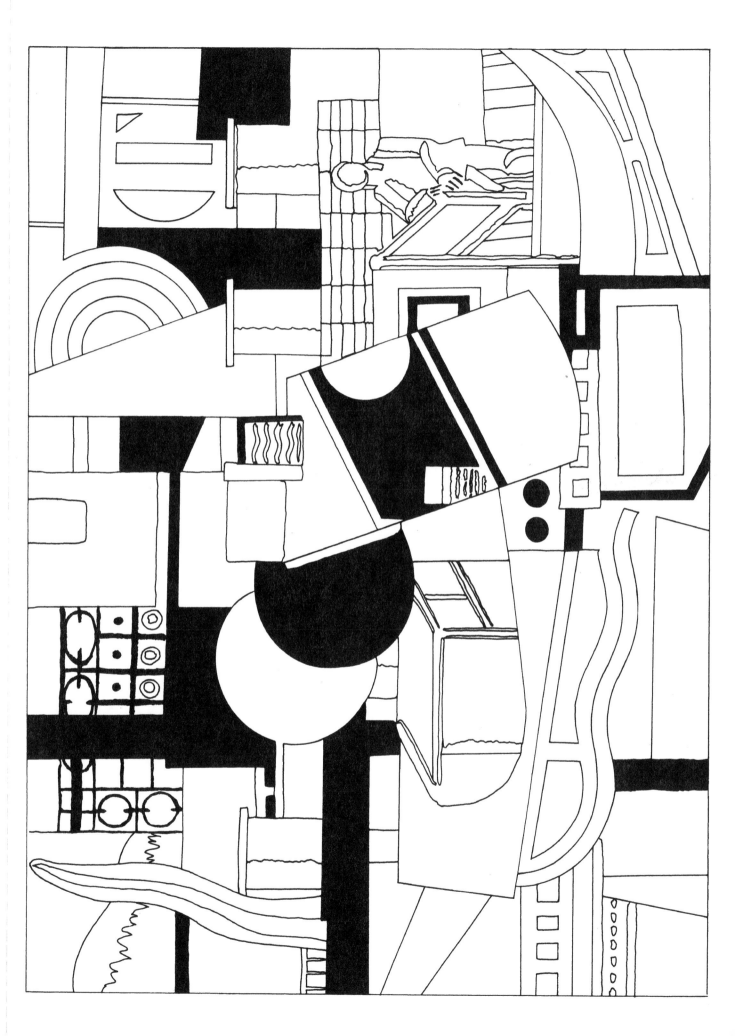

Plate 16
FERNAND LÉGER
The Deck of the Tugboat, 1920

Born the son of a cattle farmer in Argenta, France, Fernand Léger apprenticed as an architect for two years before moving to Paris in 1900. There, he studied painting at the School of Decorative Arts and the École des Beaux-Arts, while supporting himself as a draftsman at a nearby architectural firm. Greatly influenced by the work of Cézanne and the Cubists, Léger would go on to form his own unique style of Cubism, characterized by machine-like elements and tubular forms. This style, nicknamed "tubism" and often referred to as "machine art" can be readily seen in the mechanistic shapes and forms that comprise *The Deck of the Tugboat.*

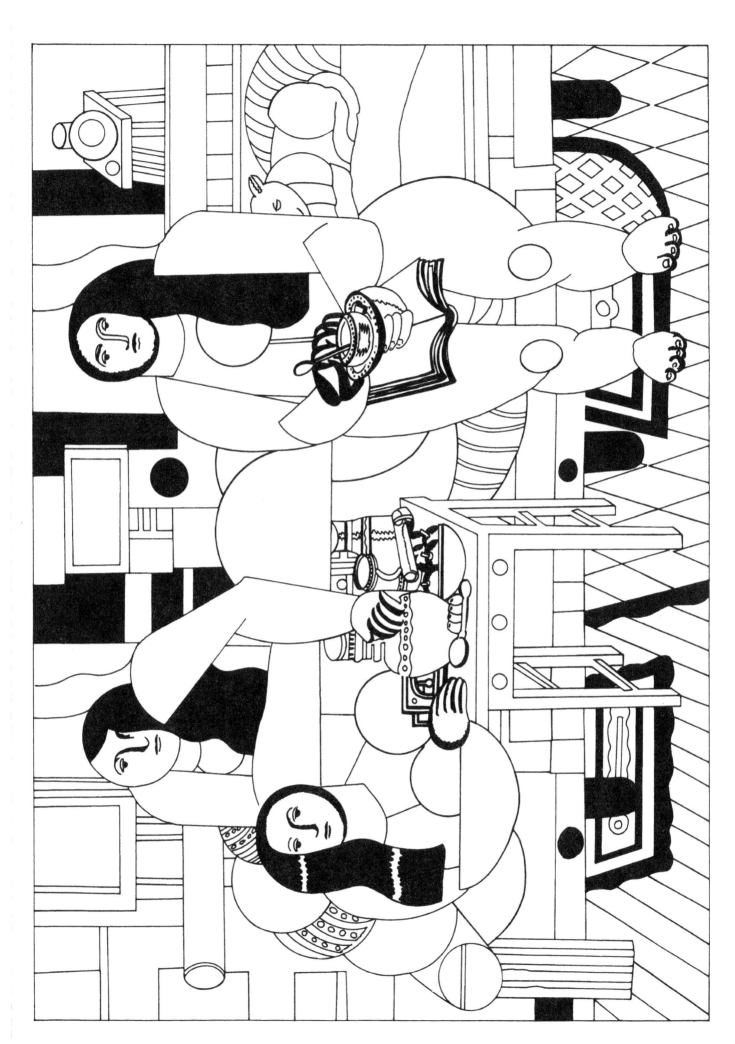

Plate 17
FERNAND LÉGER
Three Women, 1921

Born the son of a cattle farmer in Argenta, France, Fernand Léger apprenticed as an architect for two years before moving to Paris in 1900. There, Léger studied painting at the School of Decorative Arts and the École des Beaux-Arts, while supporting himself as a draftsman at a nearby architectural firm. Greatly influenced by the work of Cézanne and the Cubists, Léger would go on to form his own unique style of Cubism, characterized my machine-like elements and tubular forms. Although the subject of *Three Women* is a group of reclining nudes sipping coffee in an apartment, his "machine art" style can still be observed in the mechanistic way the three subjects are depicted.

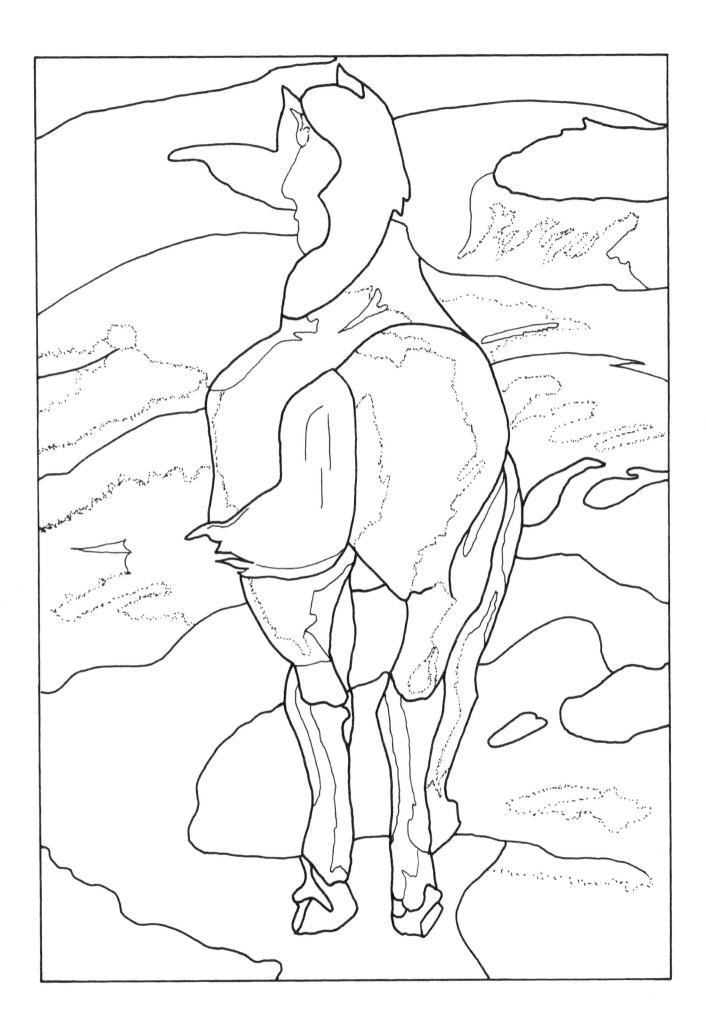

Plate 18
FRANZ MARC
Blue Horse, 1911

The son of a professional landscape painter, Franz Marc was born and raised in Munich, where he studied painting at the Academy of Fine Arts. Marc is best known as one of the most important artists in the German Expressionist movement, and as a founding member of the Expressionist artists' group known as *The Blue Ryder. Blue Horse* is typical of Marc's work during his association with *The Blue Ryder* in its simple, almost Cubist depiction of animal life and its bold use of primary colors.

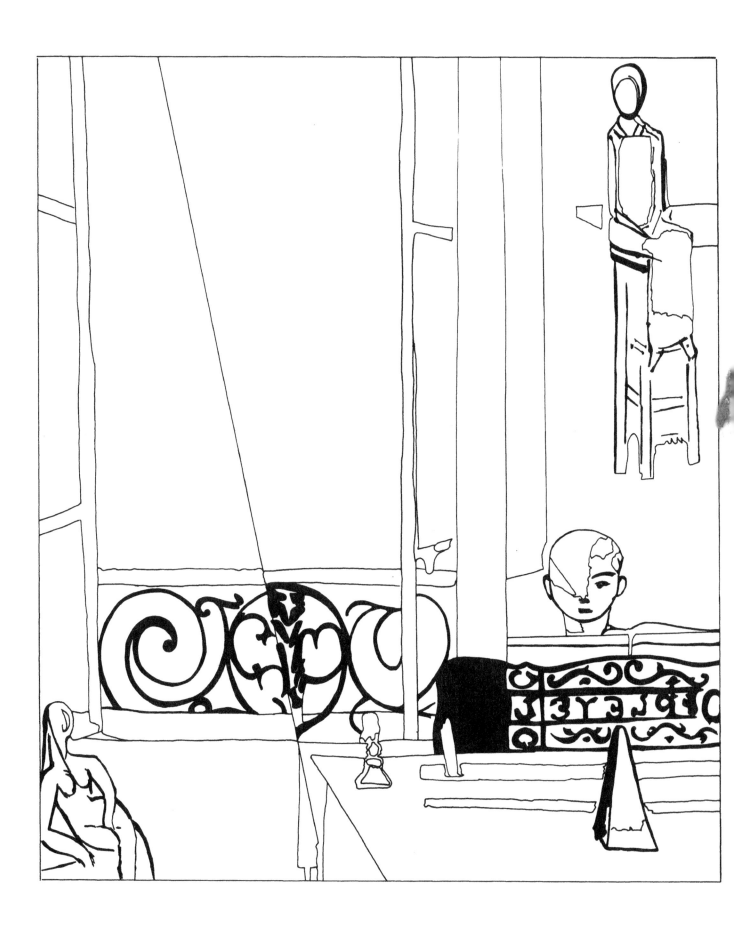

Plate 19
HENRI MATISSE
The Piano Lesson, **1916**

French artist Henri Matisse abandoned his early studies in law to attend the Académie Julian and the École des Beaux Arts in Paris when he was in his early twenties. Matisse, the most famous representative of the art movement known as Fauvism, used bold color to stir the emotions of viewers. The Fauvists created innovative works of vivid intensity through their use of pure color. Matisse's later works included more abstraction, as in his collages of colored paper cutouts. *The Piano Lesson* depicts a scene in Matisse's living room at his home in Issy-les-Moulineaux. The boy at the piano is the artist's eldest son, Pierre.

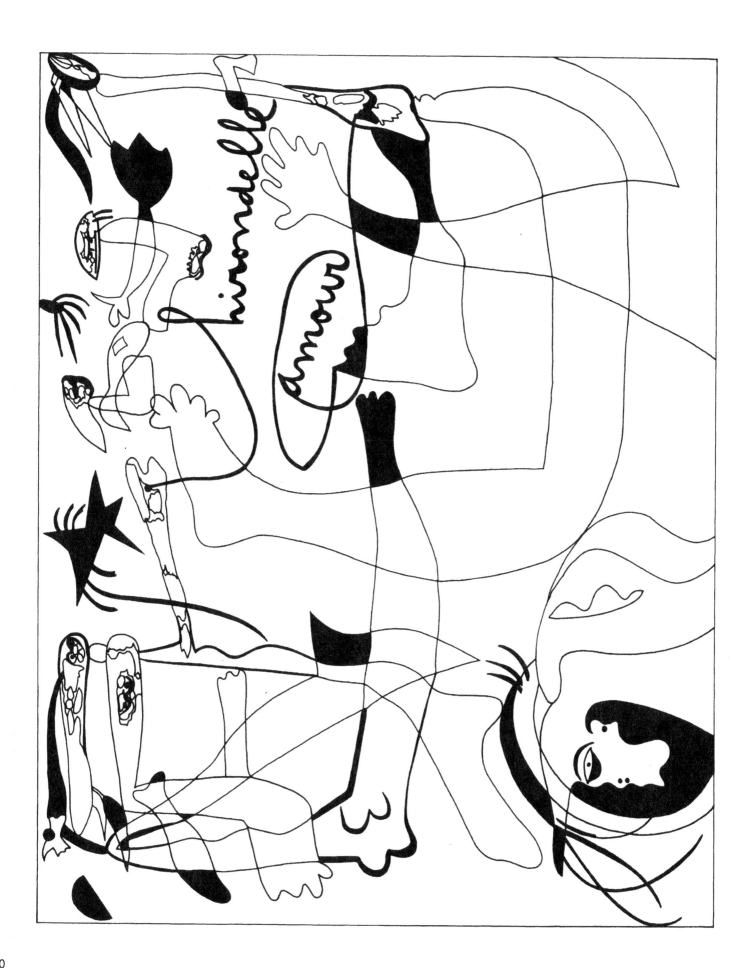

Plate 20
JOAN MIRÓ
The Swallow of Love, **1934**

Born in Barcelona, Joan Miró manifested an inclination toward art early in life. He studied at the La Lonja School of Fine Arts, where one of his instructors called his attention to Catalan primitive art—an influence that continued throughout his career. Although his early works reflect the influences of Cézanne, van Gogh, Cubism, and Fauvism, Miró soon allied himself firmly with the Surrealist movement. His work underwent a long and complex development, but some common elements include the bold use of color and curvilinear shapes. He also produced collages, ceramics, murals, etchings, and lithographs. *The Swallow of Love* is one of Miró's most recognizable paintings. It resides in the collection of the Museum of Modern Art in New York.

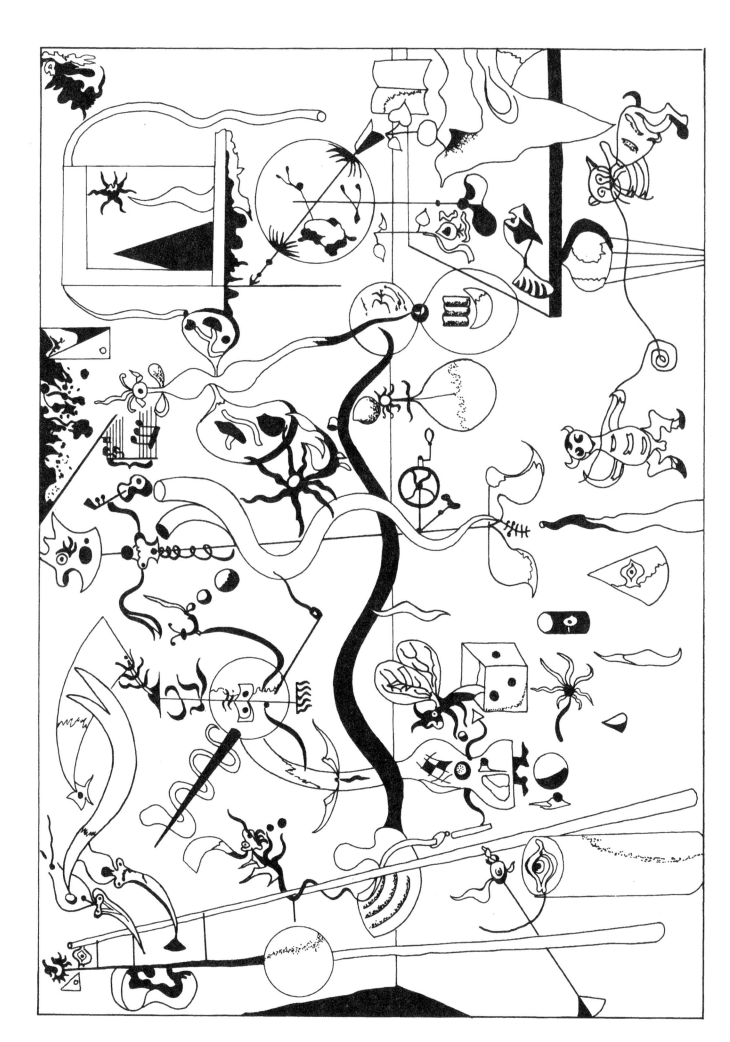

Born in Barcelona, Joan Miro manifested an inclination toward art early in life. He studied at the La Lonja School of Fine Arts, where one of his instructors called his attention to Catalan primitive art—an influence that continued throughout his career. Although his early works reflect the influences of Cézanne, van Gogh, Cubism and Fauvism, Miró soon allied himself firmly with the Surrealist movement. His work underwent a long and complex development, but some common elements include the bold use of color and curvilinear shapes. He also produced collages, ceramics, murals, etchings, and lithographs. One of the artist's most clearly surrealist works, *The Harlequin's Carnival* is filled with pictorial symbols that Miró used, in his own words, "to deepen the magical side of things."

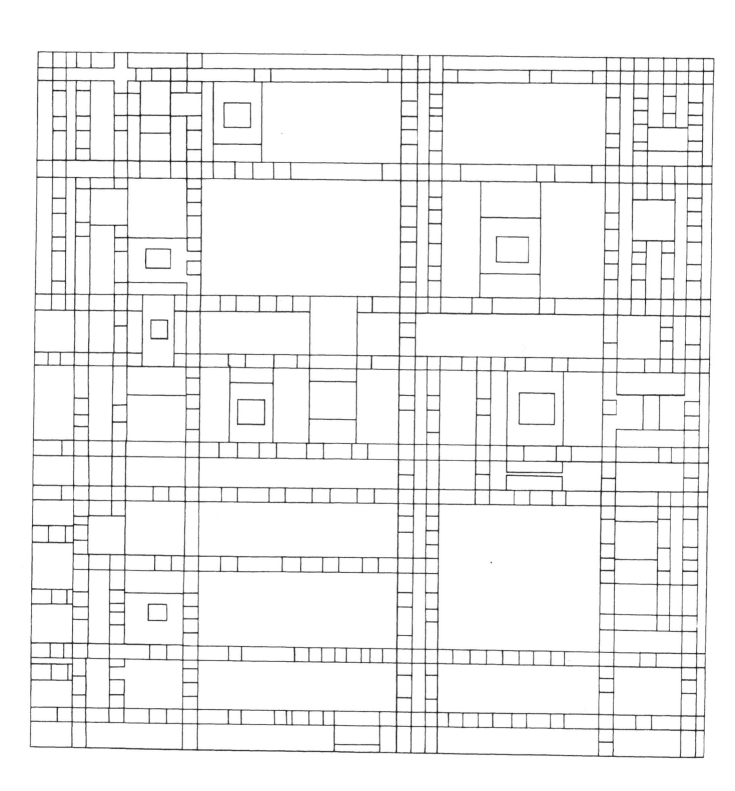

Plate 22
PIET MONDRIAN
Broadway Boogie Woogie, 1943

A pioneer of abstract art, Dutch painter Piet Mondrian came from an artistic family. After moving to Paris in 1909, his work was greatly influenced by Cubism, and with time, Mondrian's compositions became increasingly more abstract. His first abstract paintings were composed of rhythmical horizontals and verticals, followed by those with geometrical grid patterns. After 1920, he began to paint pictures of colored rectangles with black outlines, a trend that enabled him to focus on the beauty of the simple relationships between pure colors. In *Broadway Boogie Woogie,* tiny blocks of brilliant color create a pulsing rhythm that jumps from one intersection to another, mimicking the vitality of a New York City street.

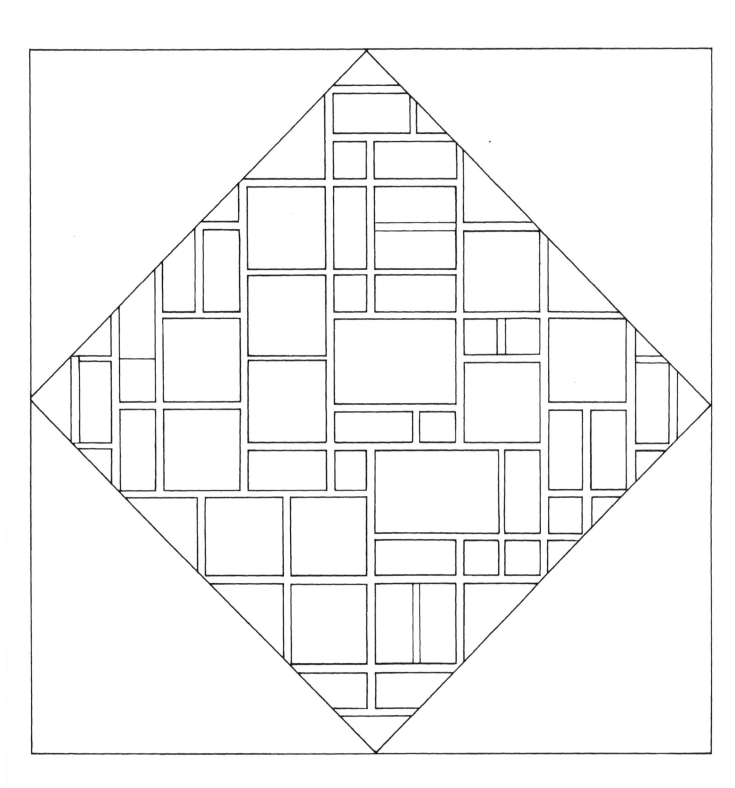

Plate 23
PIET MONDRIAN
Composition with Grid VII, 1919

A pioneer of abstract art, Dutch painter Piet Mondrian came from an artistic family. After moving to Paris in 1909, his work was greatly influenced by Cubism, and with time, Mondrian's compositions became increasingly more abstract. His first abstract paintings were composed of rhythmical horizontals and verticals, followed by those with geometrical grid patterns. After 1920, he began to paint pictures of colored rectangles with black outlines, a trend that enabled him to focus on the beauty of the simple relationships between pure colors. *Composition with Grid VII* is one of Mondrian's earliest grid paintings, painted shortly after his return to Paris after World War I.

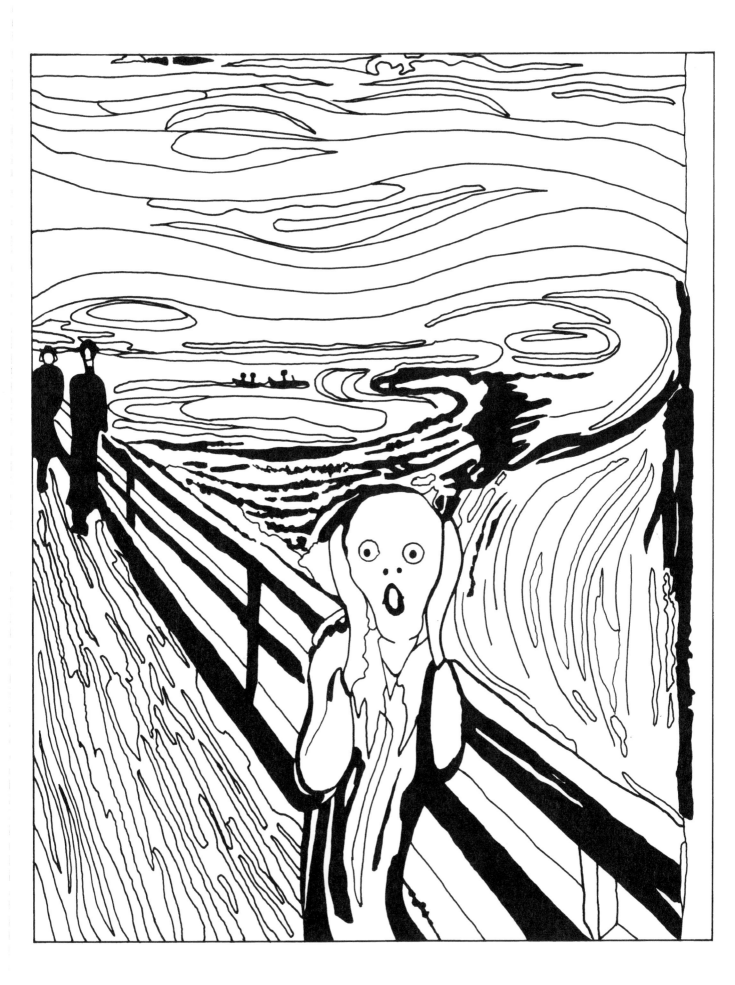

Plate 24
EDVARD MUNCH
The Scream, 1893

A forerunner of the Expressionists, Norwegian artist Edvard Munch studied at the Oslo Academy, and then traveled to Paris, where he was largely influenced by the Symbolists and Gauguin. As with many artists, a lot of Munch's subject matter was drawn directly from his own life experiences. He produced intensely powerful images that often portrayed fear, anxiety, love, and death. *The Scream* is one of the best-known images in the history of art, and embodies the stress and angst of modern life. It is in the collection of the Munch Museum in Oslo, Norway.

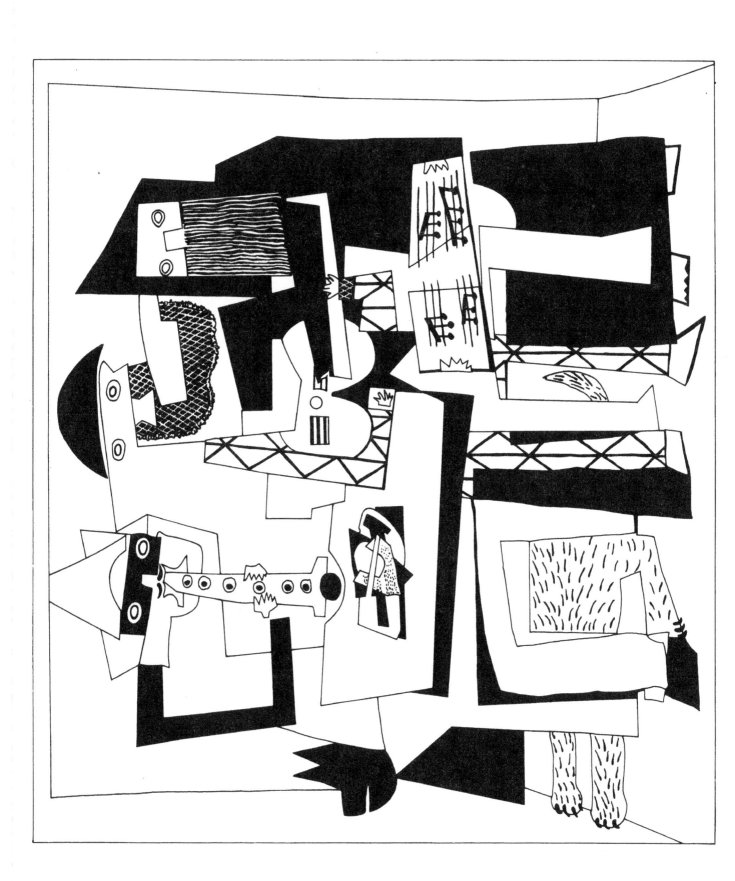

Spanish artist Pablo Picasso was one of the most inventive painters of the twentieth century. Through his extraordinary imagination and prolific output, Picasso greatly contributed to many disparate styles and major artistic movements. Although he is most famous for his canvases, he also produced outstanding sculptures, ceramics, graphics, and book illustrations. *Three Musicians* is one of two similar collage and oil paintings completed by Picasso during a stay in Fontainebleau, France, in 1921. The figures Picasso depicts in this work are a Harlequin, a Pierrot, and a monk. The version presented here resides in the collection of the Museum of Modern Art in New York.

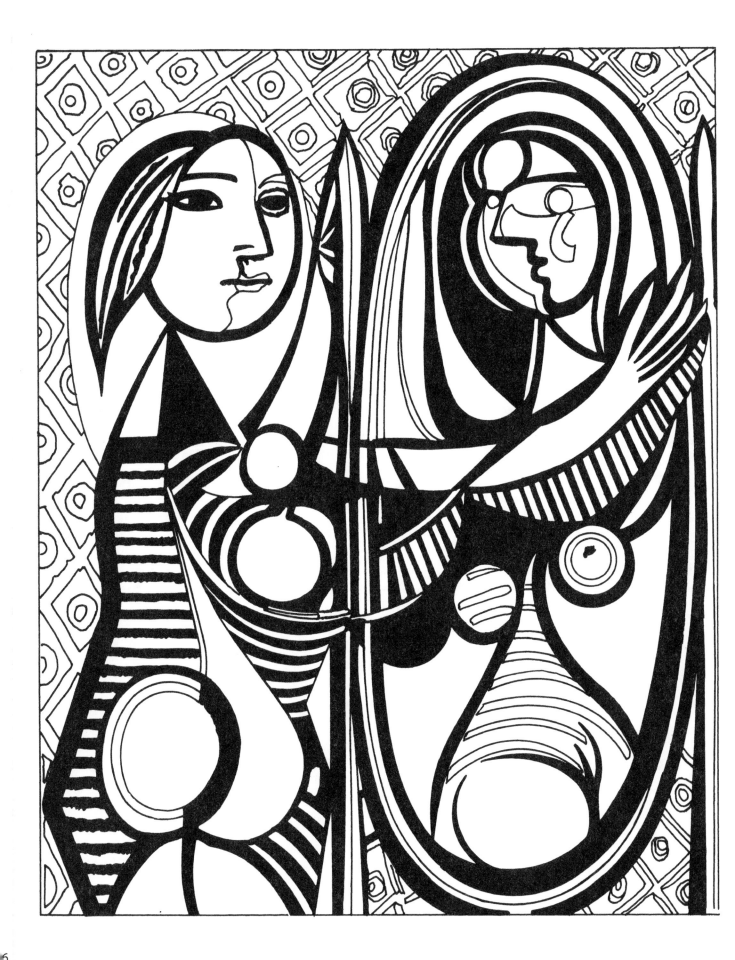

Plate 26
PABLO PICASSO
Girl Before a Mirror, **1932**

Spanish artist Pablo Picasso was one of the most inventive painters of the twentieth century. Through his extraordinary imagination and prolific output, Picasso greatly contributed to many disparate styles and major artistic movements. Although he is most famous for his canvases, he also produced outstanding sculptures, ceramics, graphics, and book illustrations. The subject of this painting is Picasso's young mistress, Marie-Thérèse Walter, whom Picasso painted many times throughout the 1930s. *Girl Before a Mirror* was inspired by Édouard Manet's famous painting, *Before the Mirror,* which also depicts a woman gazing at her own reflection.

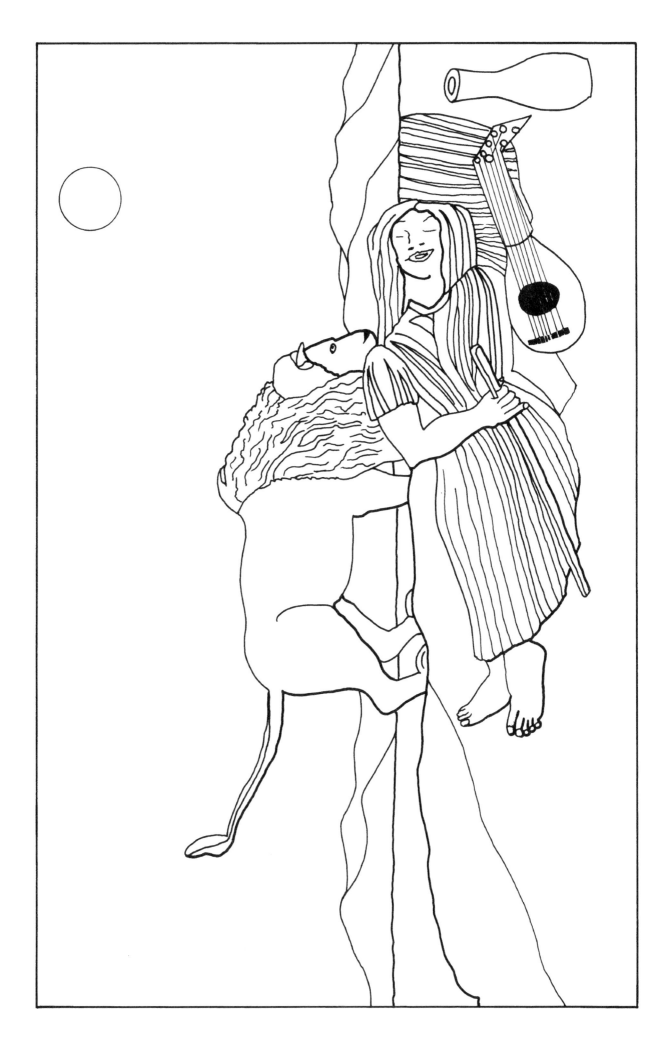

A customs officer who painted in his spare time, the French-born Rousseau had no formal artistic training, and only devoted himself exclusively to painting after his early retirement at the age of forty. Renowned for his highly stylized works, Rousseau created detailed paintings of lush foliage and mysterious figures in exotic imaginary landscapes. His portraits, still lifes, and junglescapes are examples of a manner of painting known as "naïve," a term indicative of the way an artist treated a subject in his or her own visionary way. *The Sleeping Gypsy* depicts a lion passing a sleeping woman on a moonlit night. One of the most recognizable paintings of the twentieth century, it resides in the collection of the Museum of Modern Art in New York.

Plate 28
PAUL SIGNAC
Portrait of Felix Feneon, **1890**

Originally intending to be an architect, Signac began to paint under the guidance of Monet and Guillaumin in 1880. Along with Seurat, Signac cofounded the Salon des Artistes Indépendants in 1884, and helped to further develop the Pointillist style of painting. The two artists began to fill their canvases with tiny dots of pure color using a precise, geometrical system rather than the previous methods employed by the early Impressionists. Signac was present at the Eighth Impressionist exhibition and also exhibited his works with Durand-Ruel in New York. He kept in close touch with fellow artists such as Pissarro and van Gogh, and also wrote articles on art criticism. The subject of this painting is Felix Feneon, a Parisian anarchist and art critic who was a friend of Paul Signac. *Portrait of Felix Feneon* currently resides in the collection of the Museum of Modern Art in New York.

Plate 29
ATANASIO SOLDATI
Composition, 1950

Born in Italy in 1896, Atanasio Soldati served in World War
I from 1915 to 1918 before going on to study architecture
at the Accademia di Belle Arti in Parma. Influenced by
the work of Mauro Reggiani and Piet Mondrian, Soldati
began to gain a reputation for his painting in the 1930s
and joined the Parisian artists group, Abstraction-Création
in 1936. After the destruction of his Milan studio during
the Second World War, Soldati founded the Concrete
Art Movement, along with Gillo Dorfles, Gianni Monnet,
and Bruno Munari, in defiance of the state's aesthetic of
Socialist Realism. This painting is typical of Soldati's work
during the last years of his life, in which all of his subjects
are simplified to basic, geometric shapes

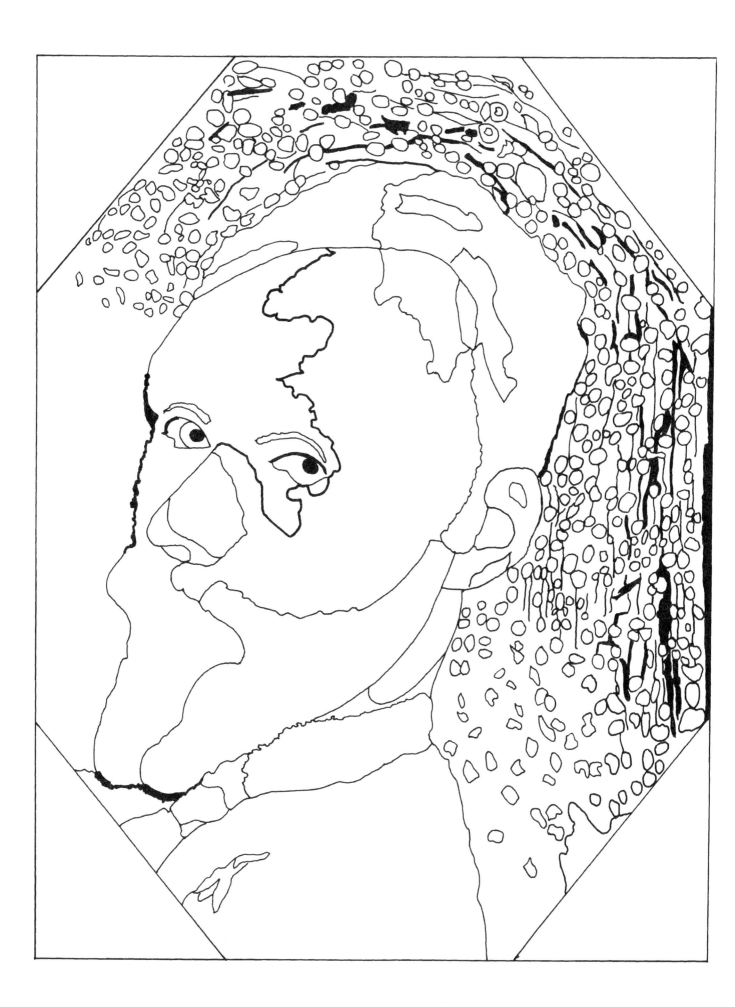

Plate 30
EDOUARD VUILLARD
Autoportrait, 1891

A cofounder of the group of Symbolist painters known as Les Nabis, Edouard Vuillard shared a studio with Bonnard and Denis. Strongly influenced by the work of Degas, Redon, and Gauguin, Vuillard carefully studied the canvases of the Impressionists. His garden scenes owe a great debt to the early paintings of Monet in his use of dappled sunlight. The sudden popularity of Japanese woodcuts had a profound effect on his compositions as well. Vuillard is best known, however, for his paintings of interiors, the bulk of which are impressively decorative domestic scenes executed with a keen sense of light and color. Vuillard produced numerous self-portraits throughout his career as an artist. This one is in the collection of the Musée d'Orsay in Paris.

GREYSCALE

BIN TRAVELER FORM

Cut By _Victor Waray_ Qty _29_ Date _____

Scanned By _____ Qty _____ Date _____

Scanned Batch IDs

_____ _____ _____

Notes / Exception
